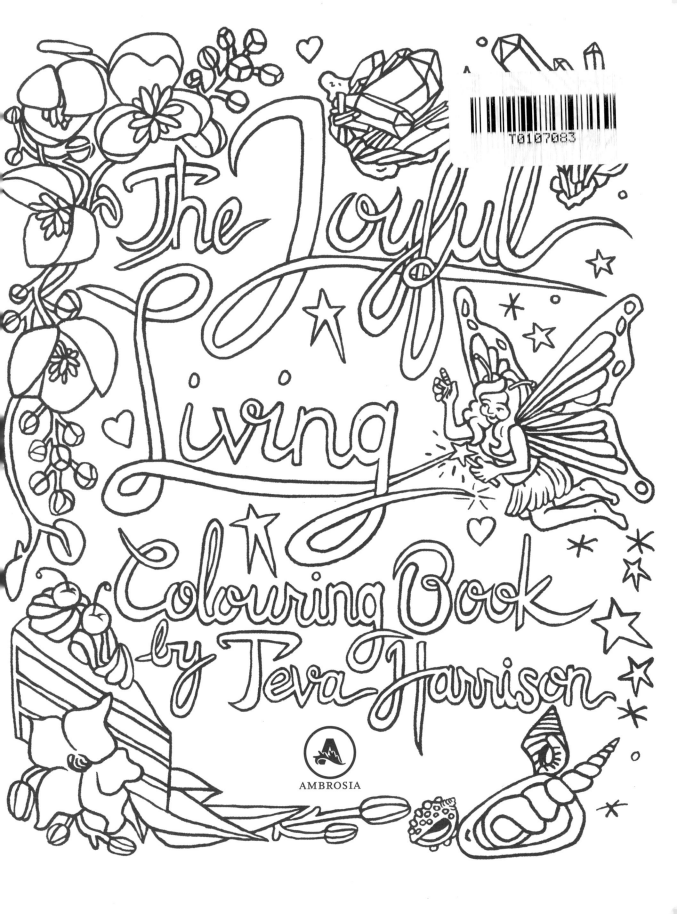

The Joyful Living Colouring Book by Teva Harrison

AMBROSIA

Published in Canada in 2016 and the USA in 2017
by House of Anansi Press Inc.
www.houseofanansi.com

House of Anansi Press is committed to protecting our natural
environment. As part of our efforts, the interior of this book is
printed on paper that contains 100% post-consumer recycled
fibres, is acid-free, and is processed chlorine-free.

20 19 18 17 16 1 2 3 4 5

Cover design: Teva Harrison

*We acknowledge for their financial support of our publishing program
the Canada Council for the Arts, the Ontario Arts Council,
and the Government of Canada through the Canada Book Fund.*

Printed and bound in Canada

This book is for you.
Now grab your pencils and make it yours!

FOR ME, DRAWING IS MAGICAL. It's cathartic and transformative. It lifts me up when I'm low. It fills me up when I'm empty. It calms my nerves when I have anxiety. And when I was diagnosed with metastatic breast cancer, drawing pulled me out of the deepest depression I've ever experienced.

The act of putting pen to paper, of allowing my imagination free rein, has been healing for me. Time spent creating helps to balance time spent in hospitals. I find peace in the creative flow. It works like meditation for me. It lets joy in.

I hope the time you spend with this book will work the same way for you—that you'll be able to carve out space for mindfulness, space to be here, now, in this moment. Taking time for yourself, to cultivate inner peace, is a challenge in this world. I know. It took a terminal diagnosis to get me to slow down. Now, I am maximizing joy in my life every way I can.

Here is my challenge to you: Carve out space in your day. Breathe into it and feel it expand. Open yourself up to the delight and possibility of this moment. Keep breathing. Reach for a colour that makes you happy. Bring the light, the brightness, and the levity of colour to paper. Get lost in the act of colouring by focusing on this moment. That's where you find the magic.

And carry that feeling forward to live joyfully.

Teva Harrison
August 2016

You do not have to be good.
You do not have to walk on your knees
For a hundred miles through the desert, repenting.
You only have to let the soft animal of your body
love what it loves.

Mary Oliver, from the poem "Wild Geese"

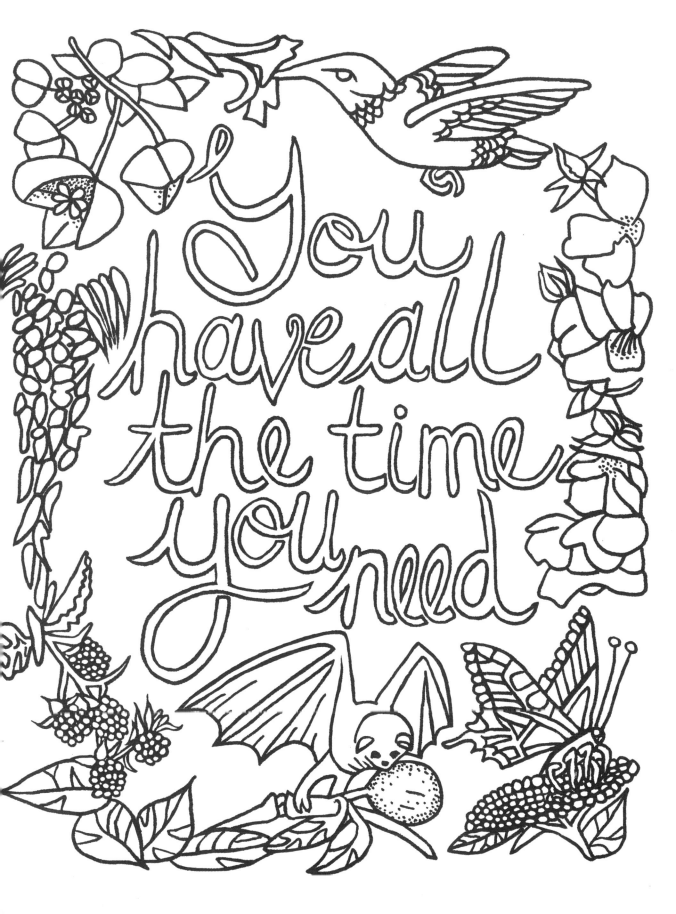

You have all the time you need

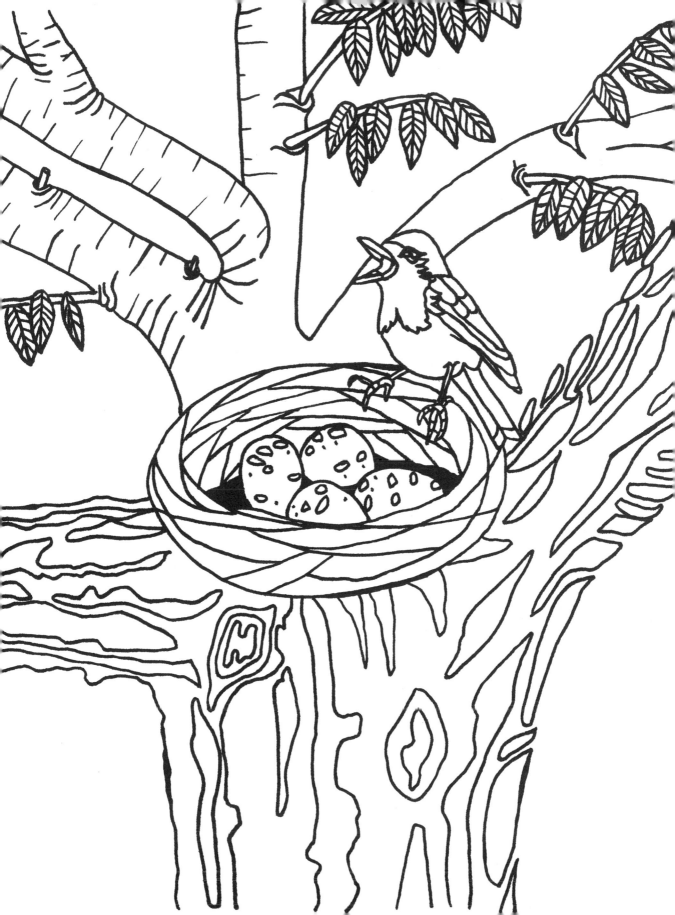

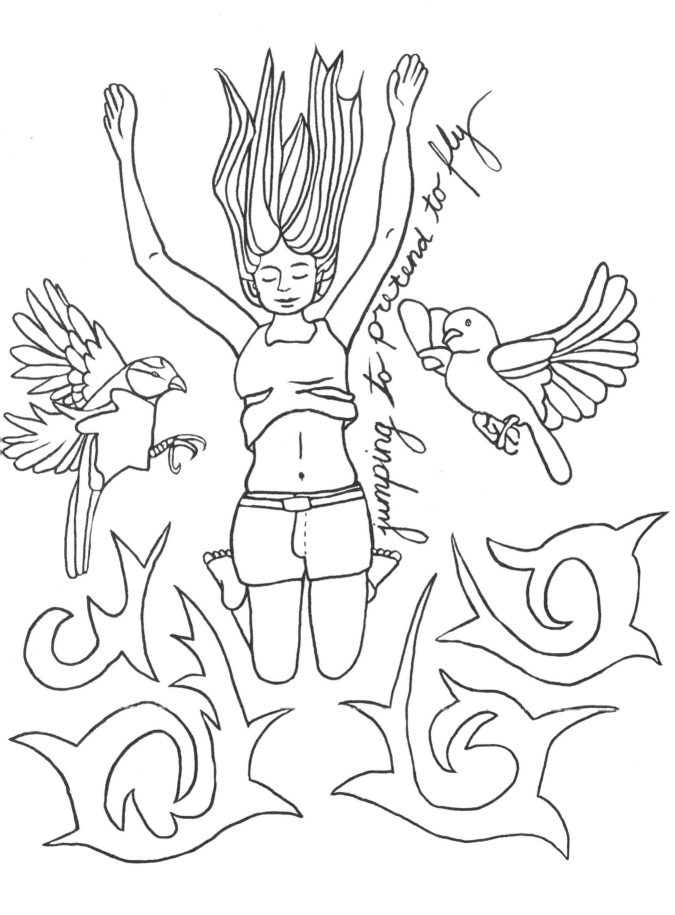

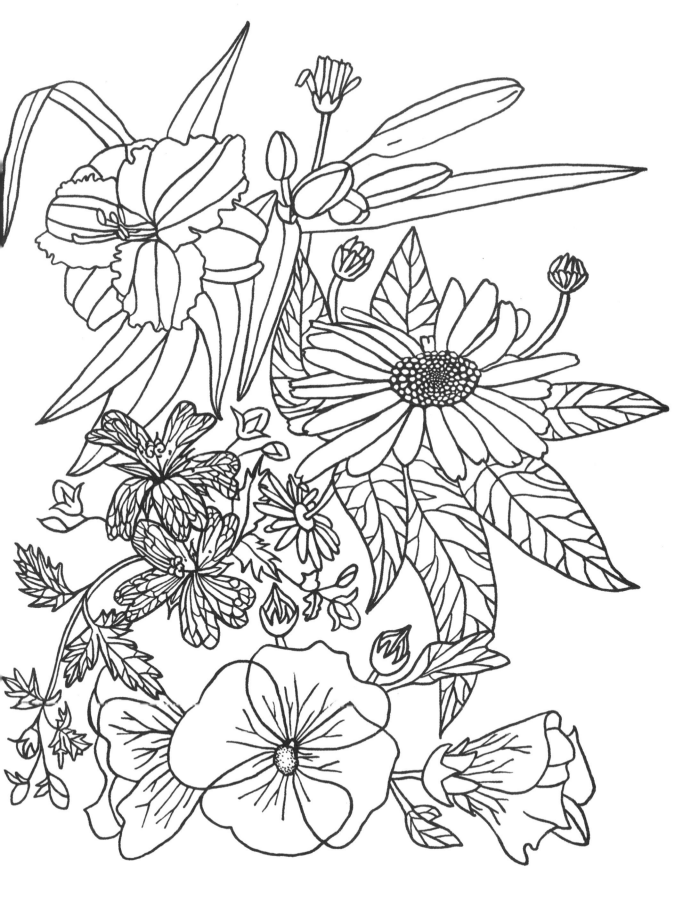

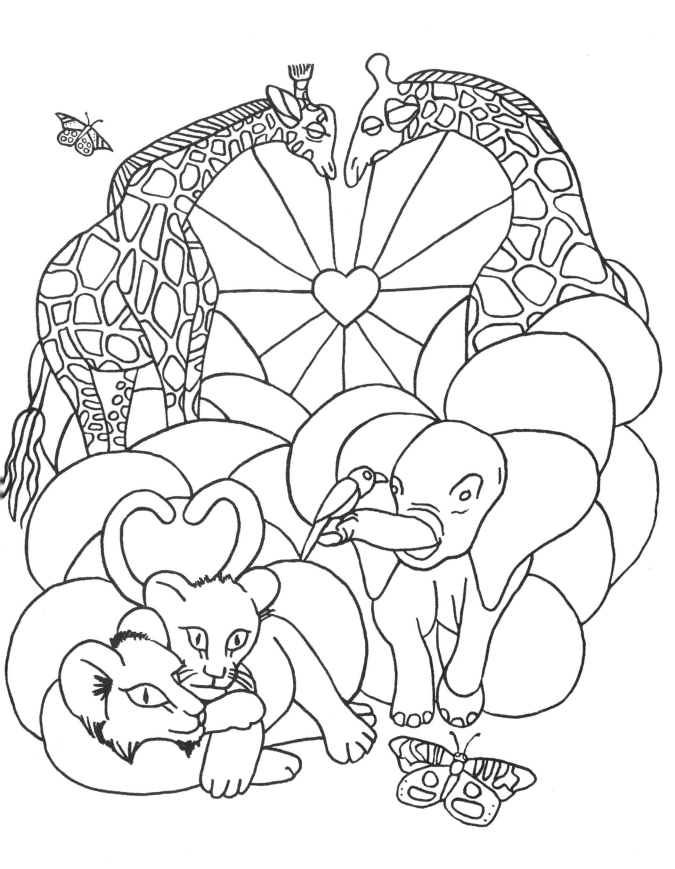

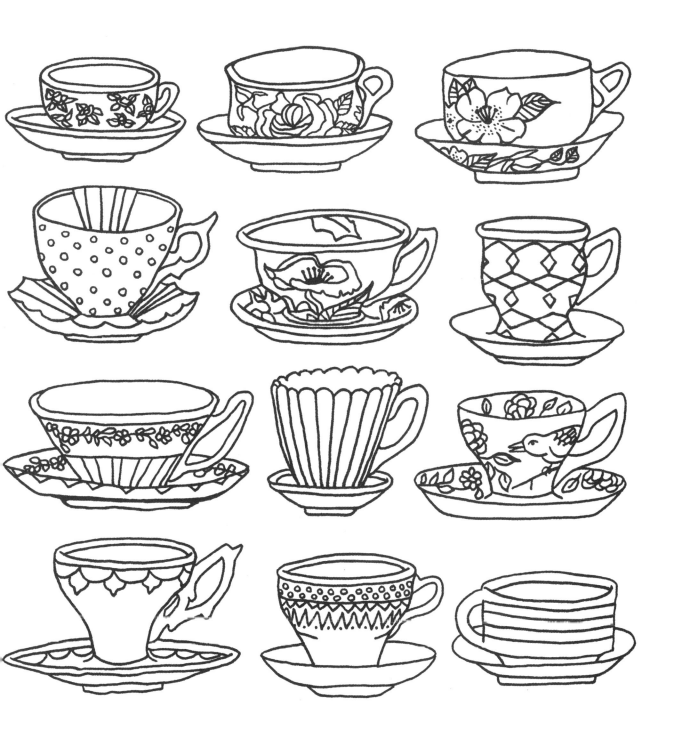

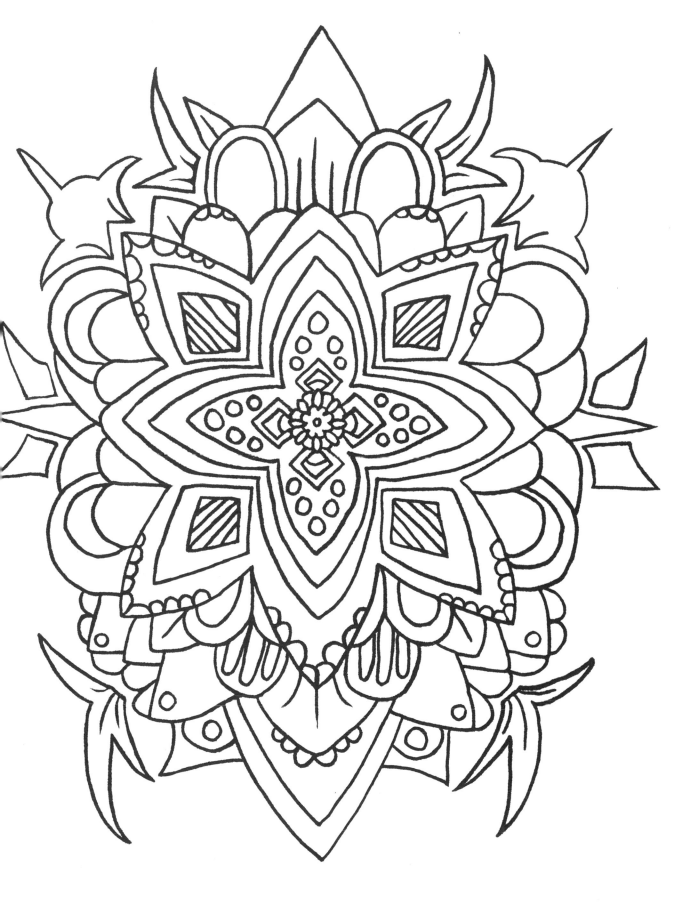

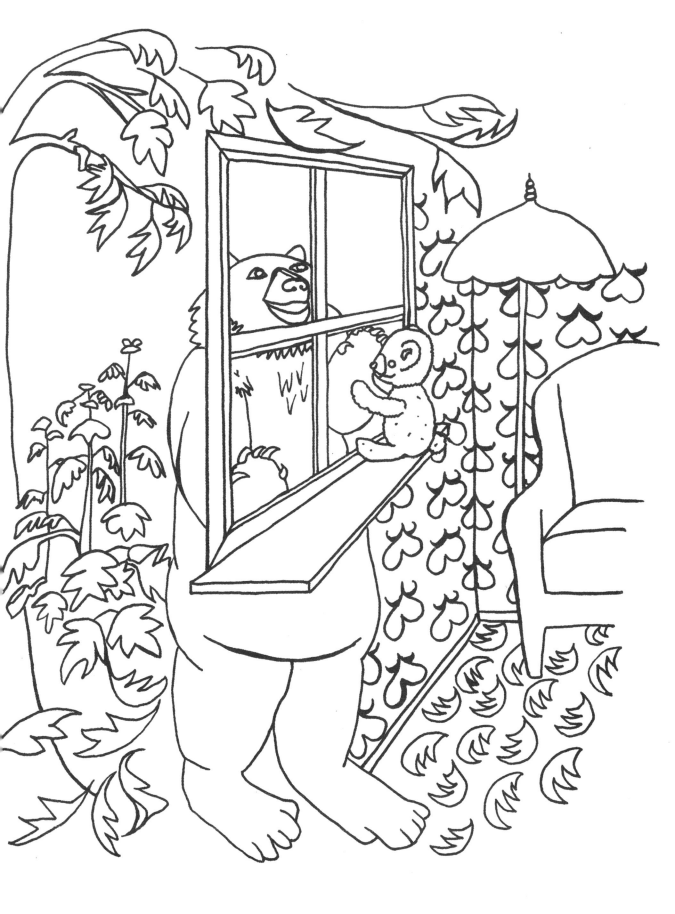

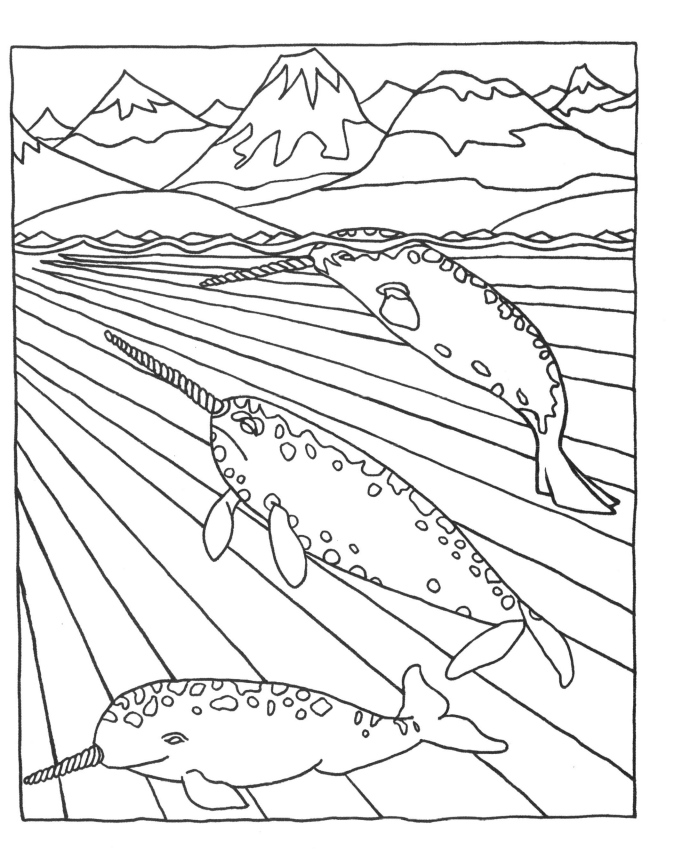

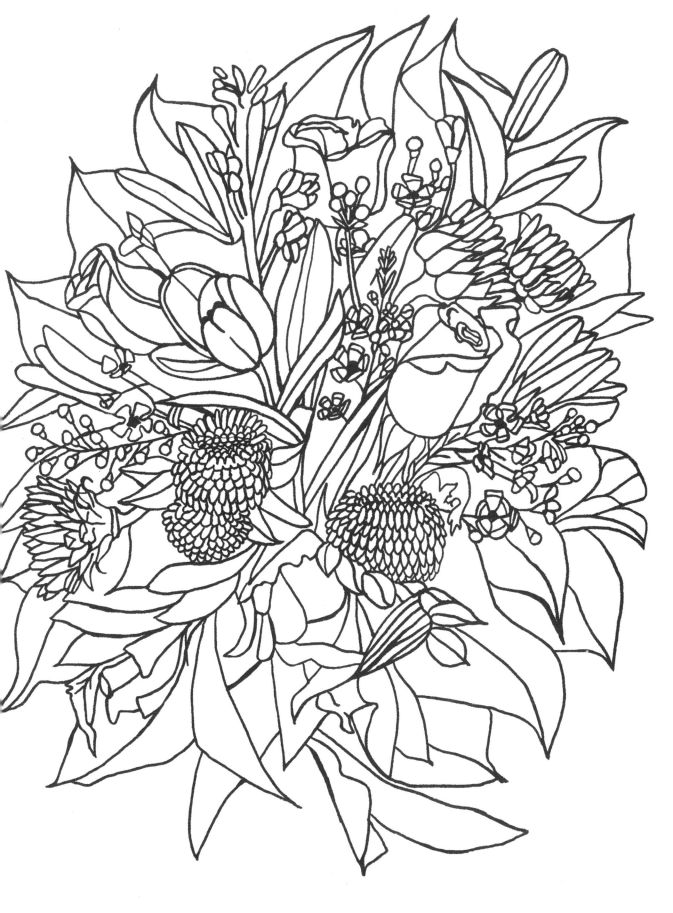

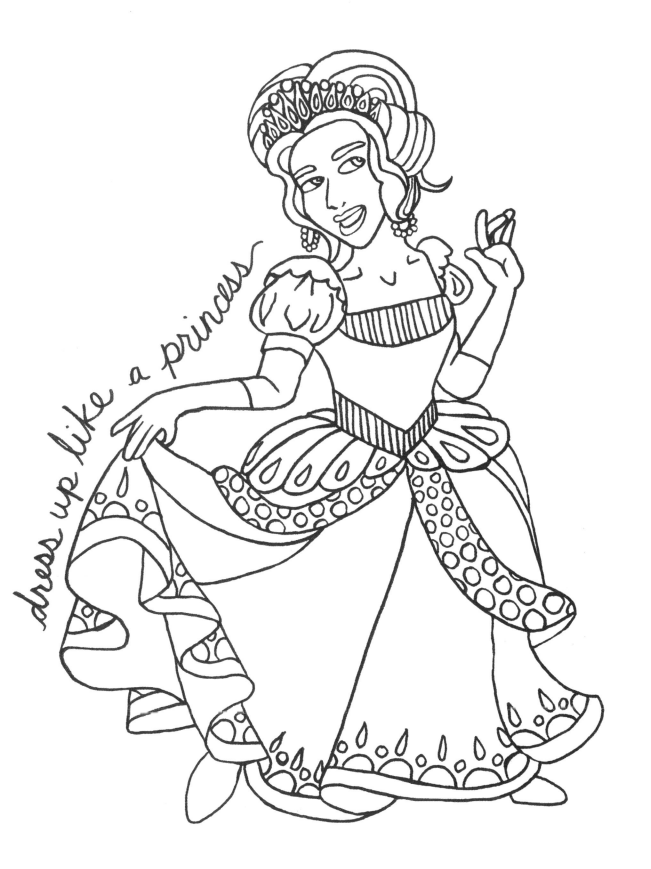

dress up like a princess

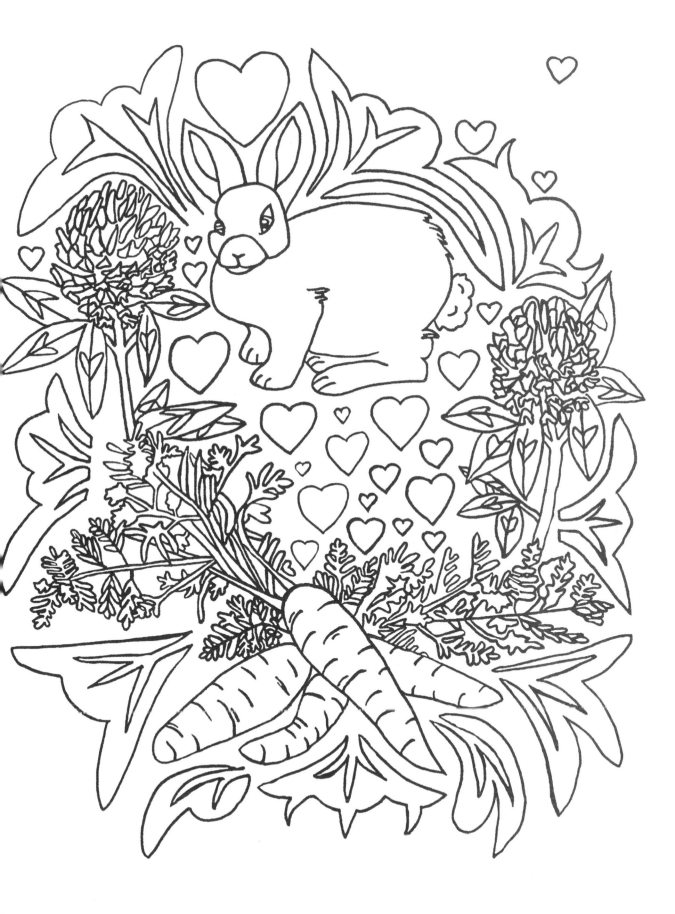

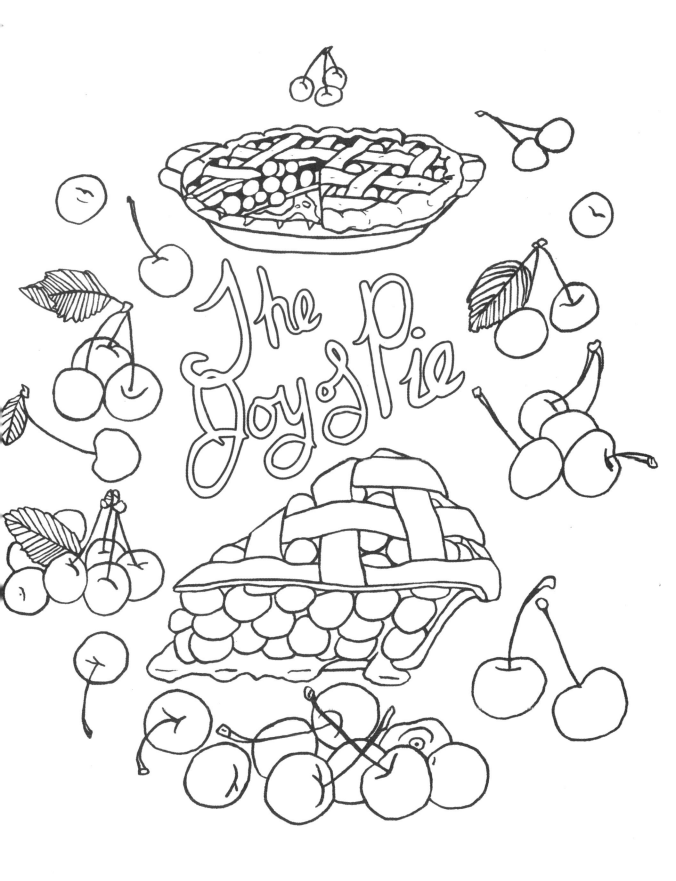

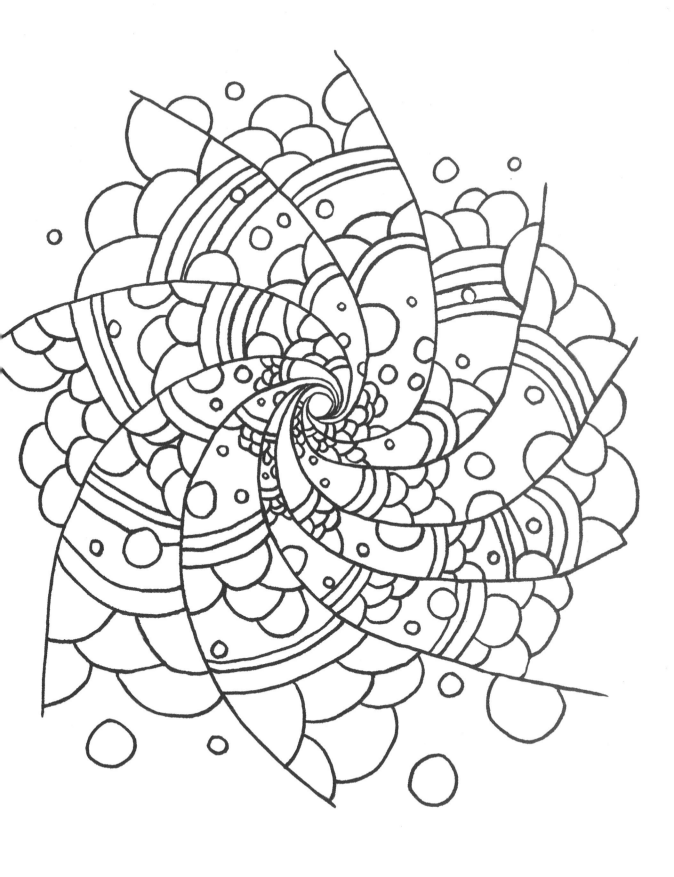

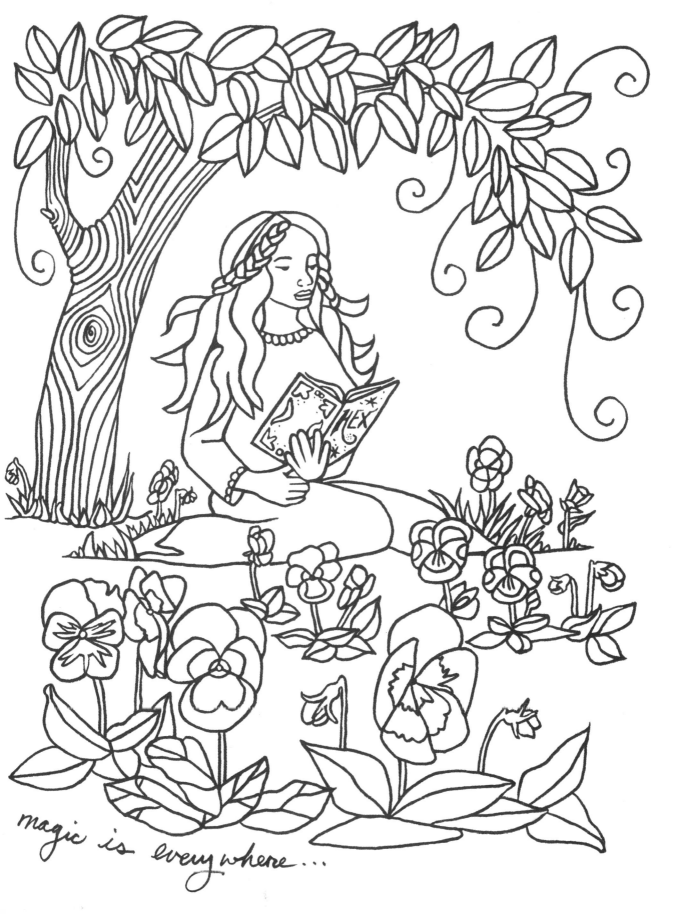

magic is everywhere...

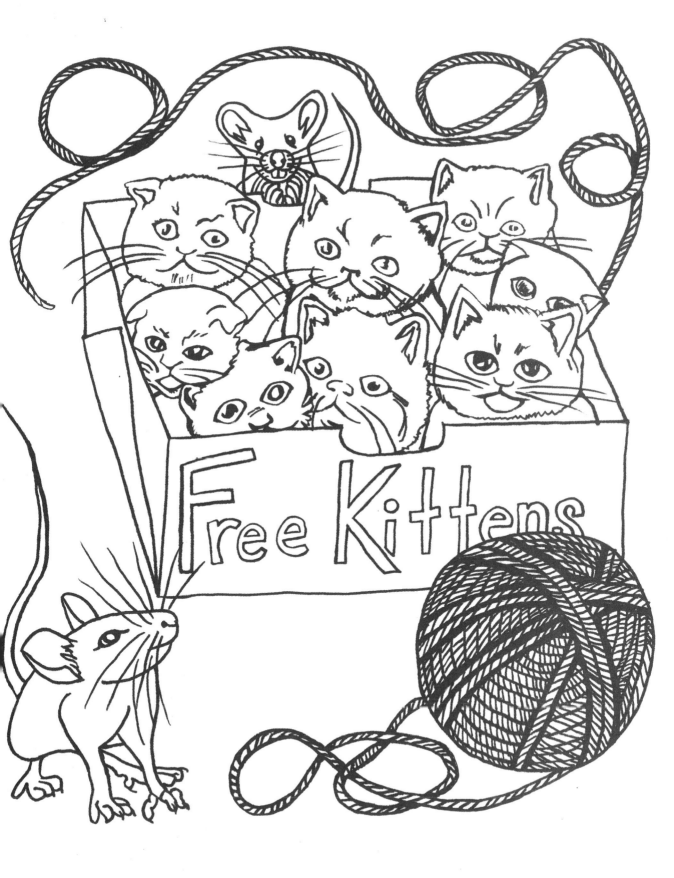

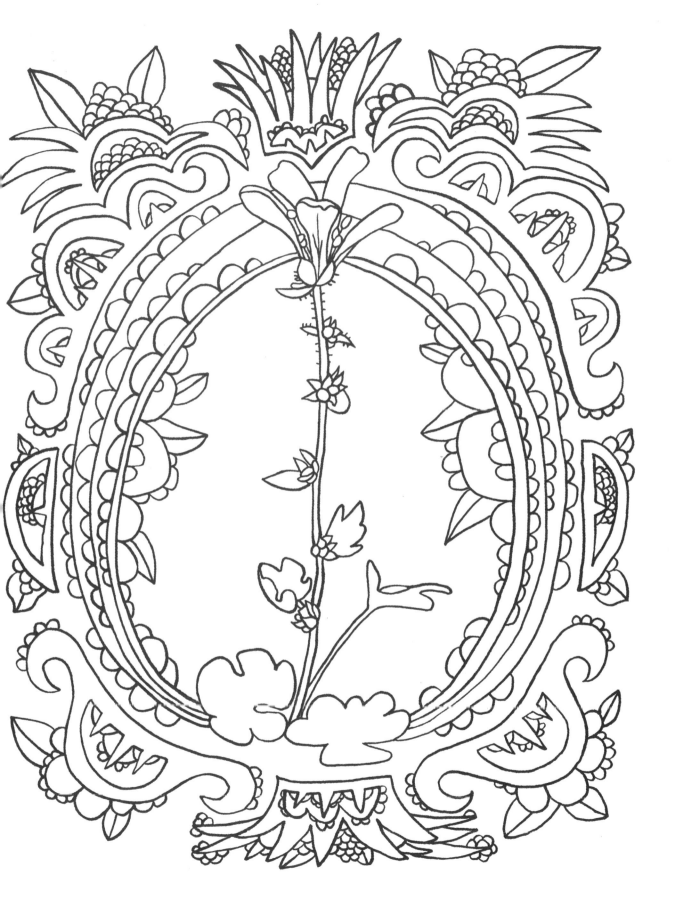

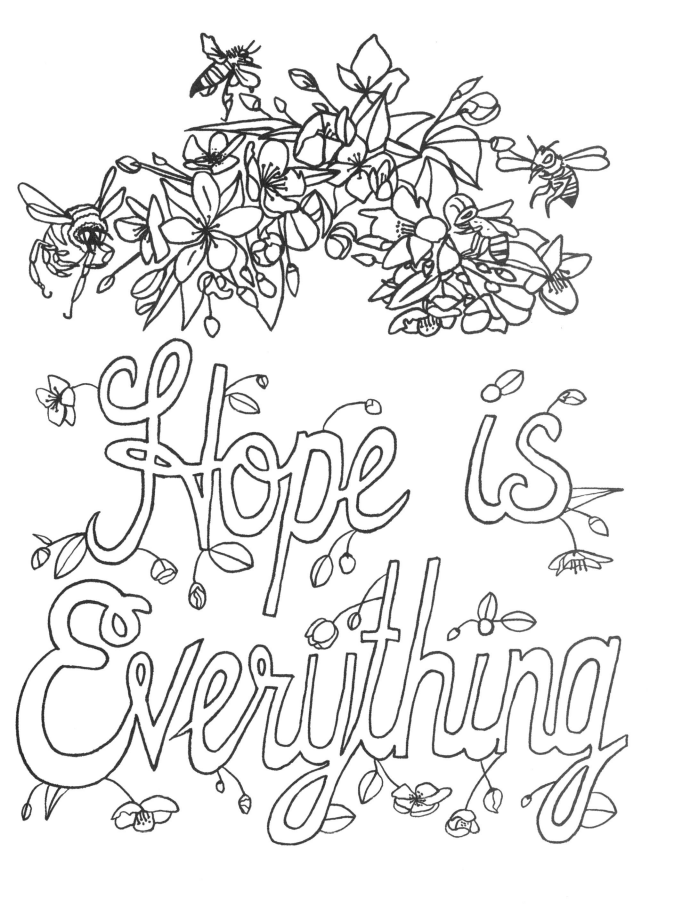

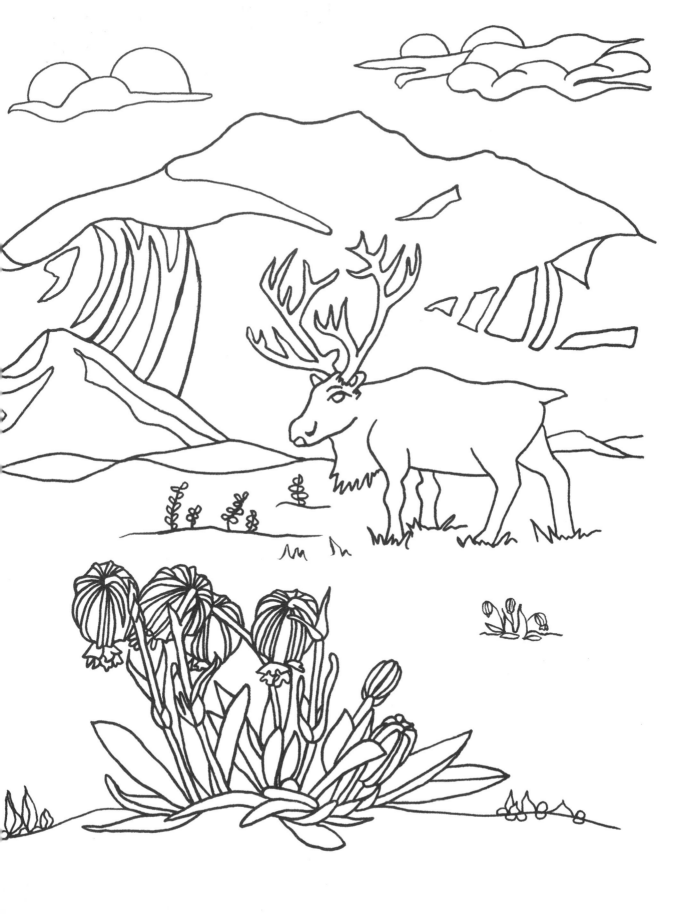

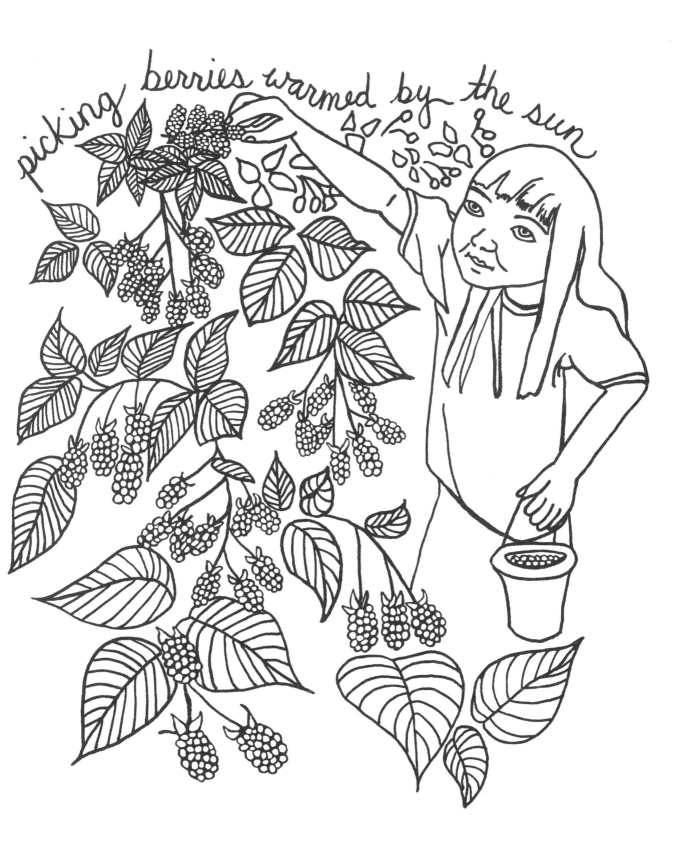

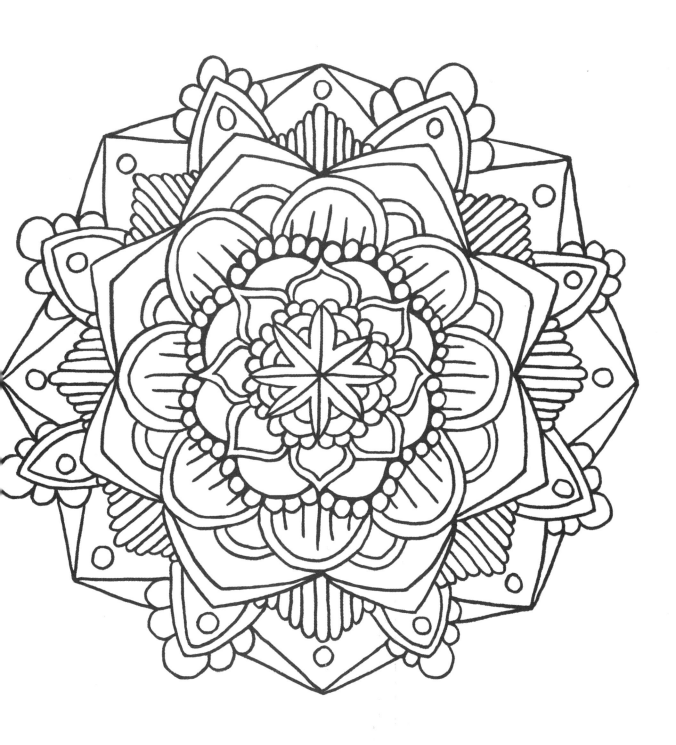

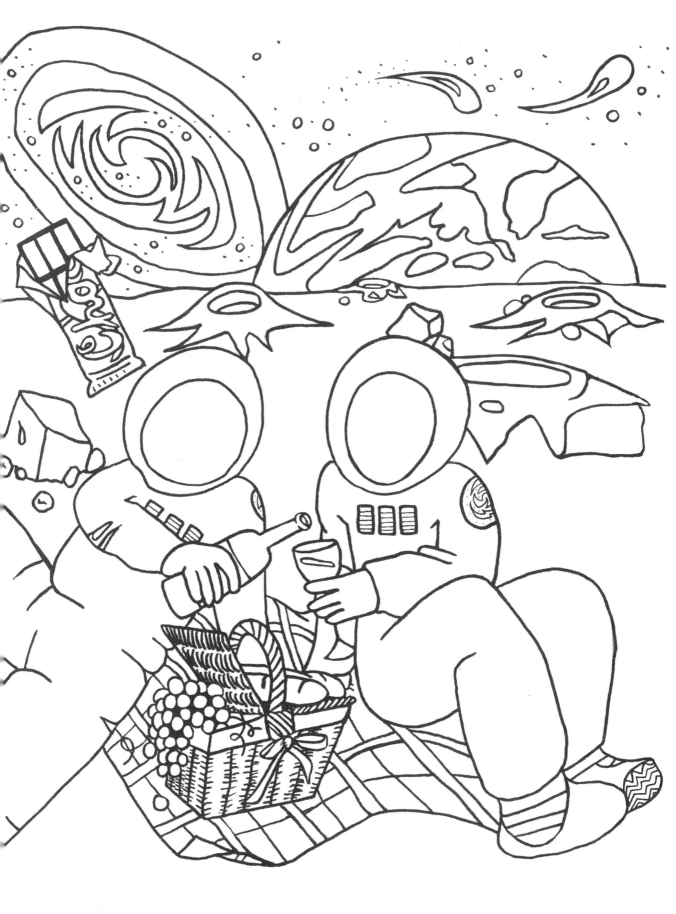

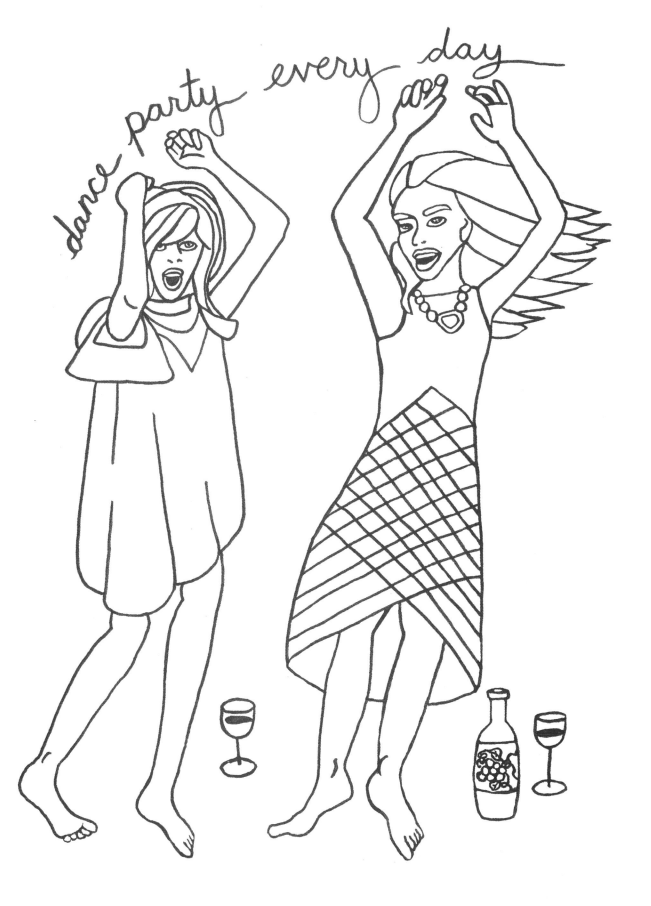

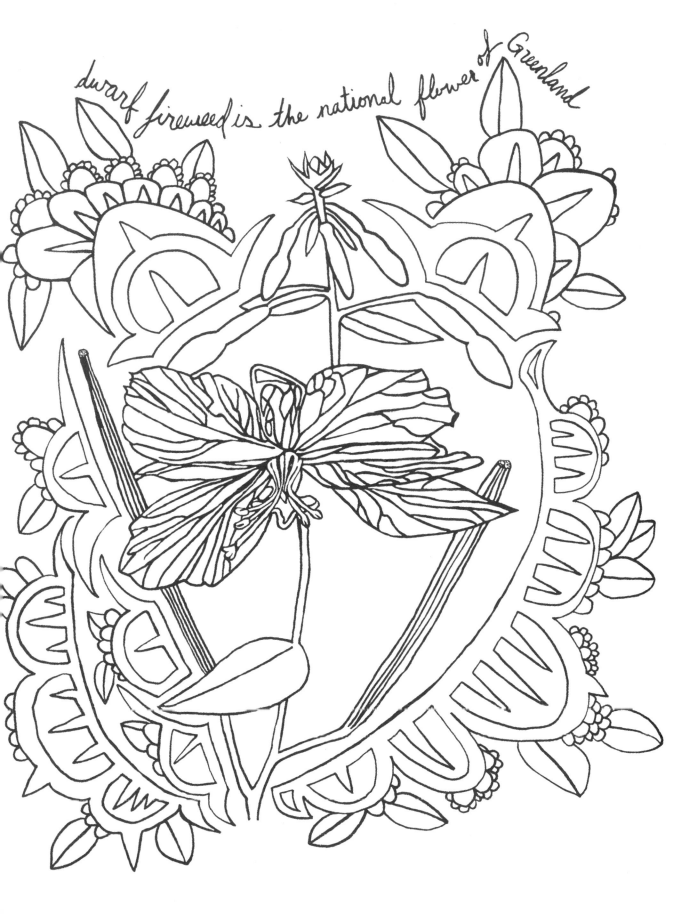

dwarf fireweed is the national flower of Greenland

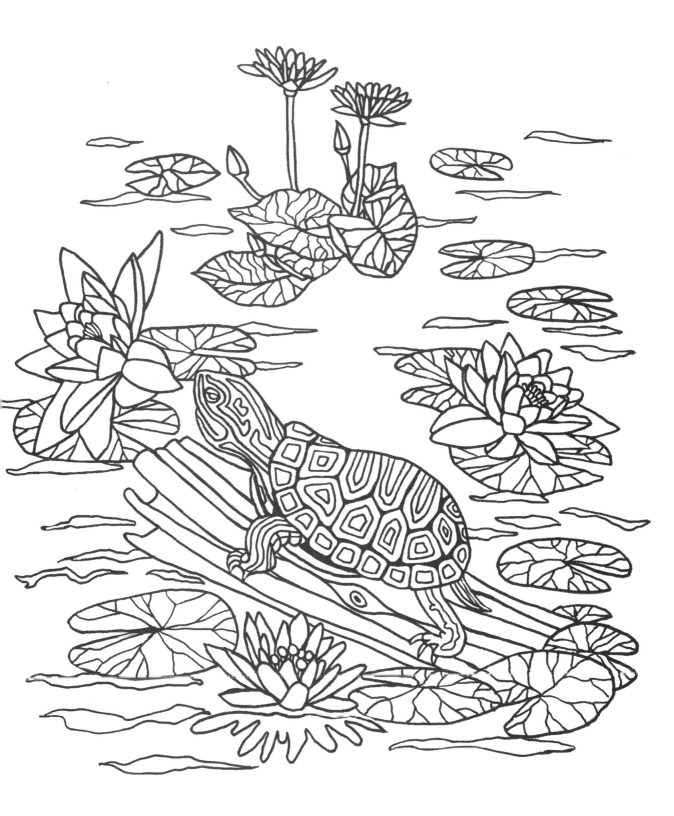

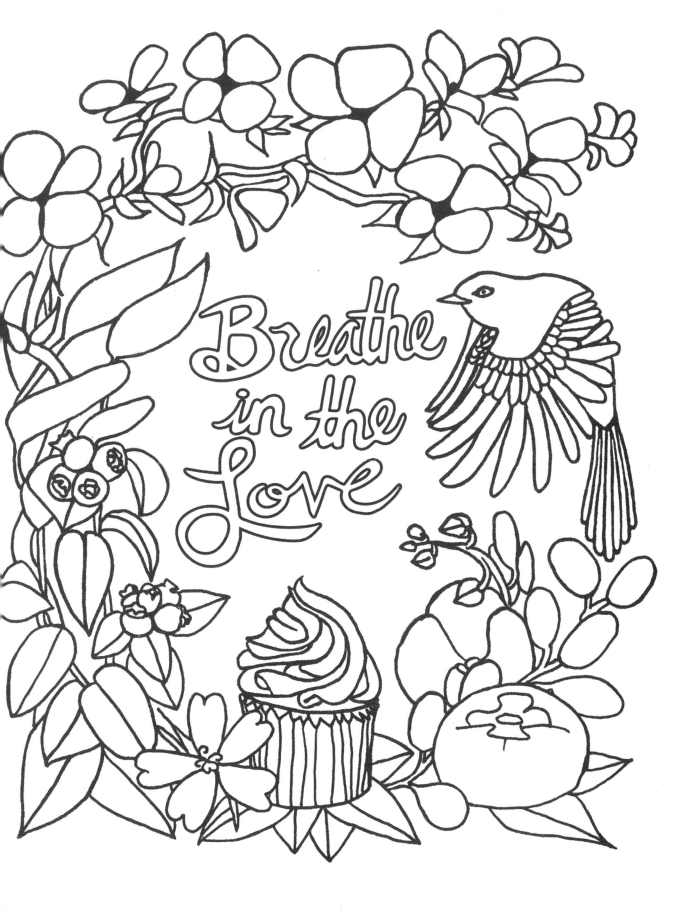

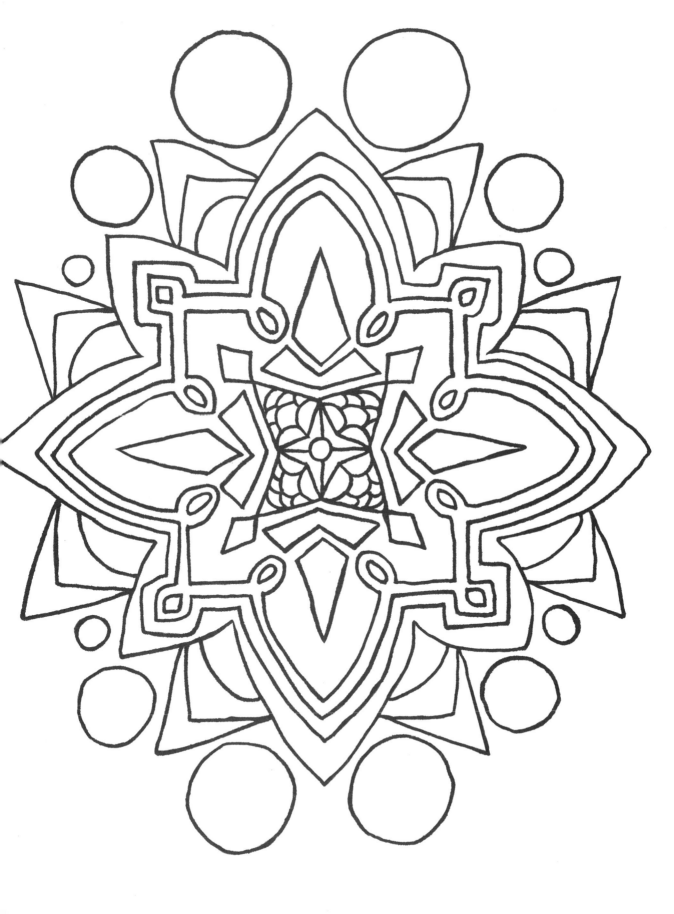

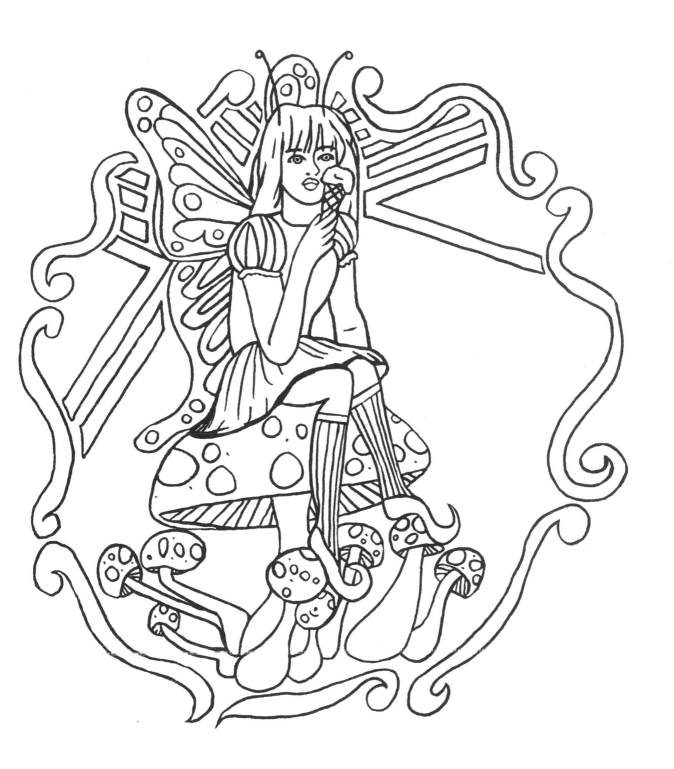

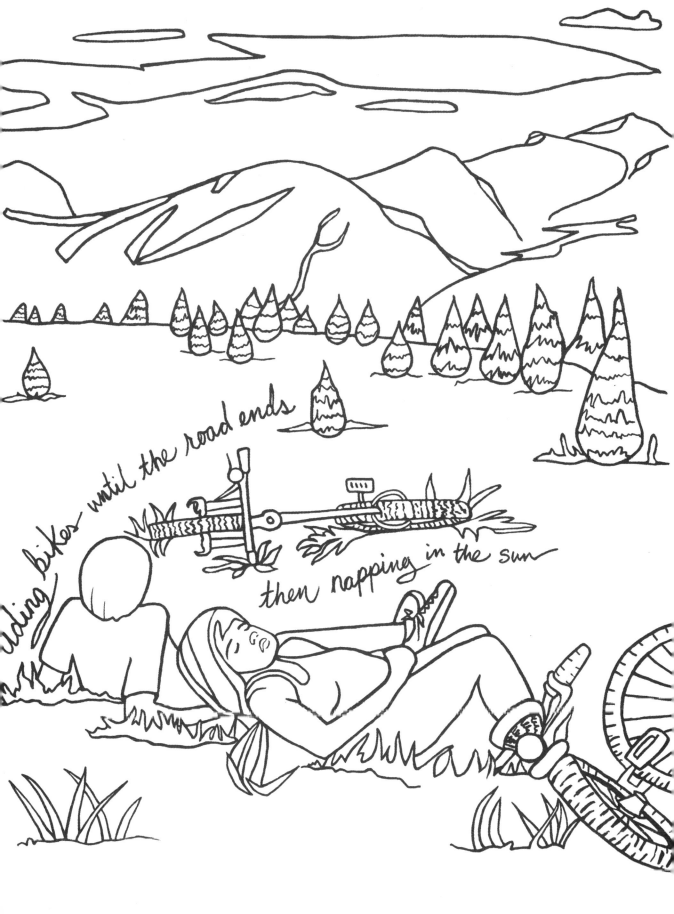

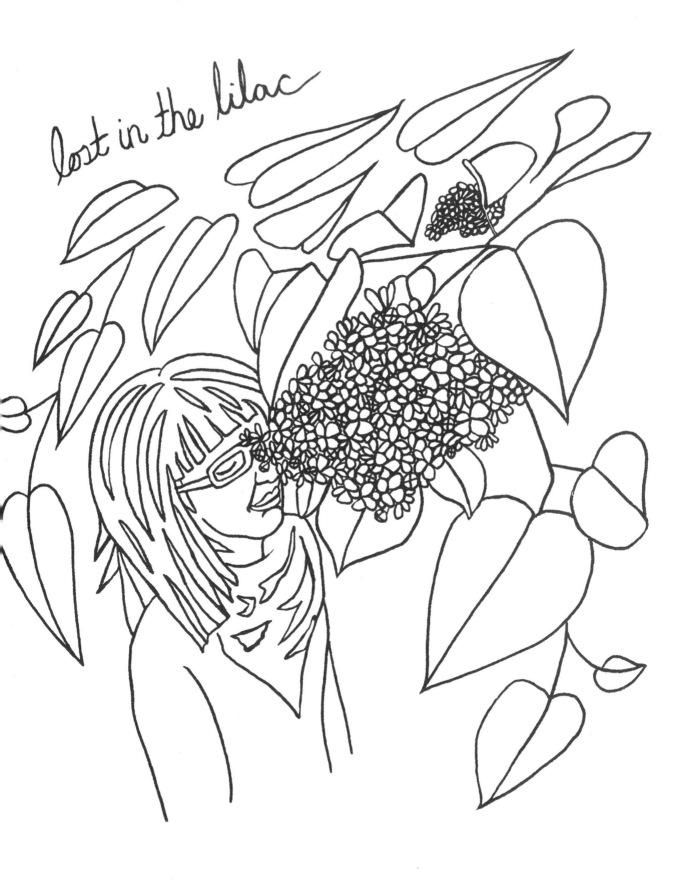

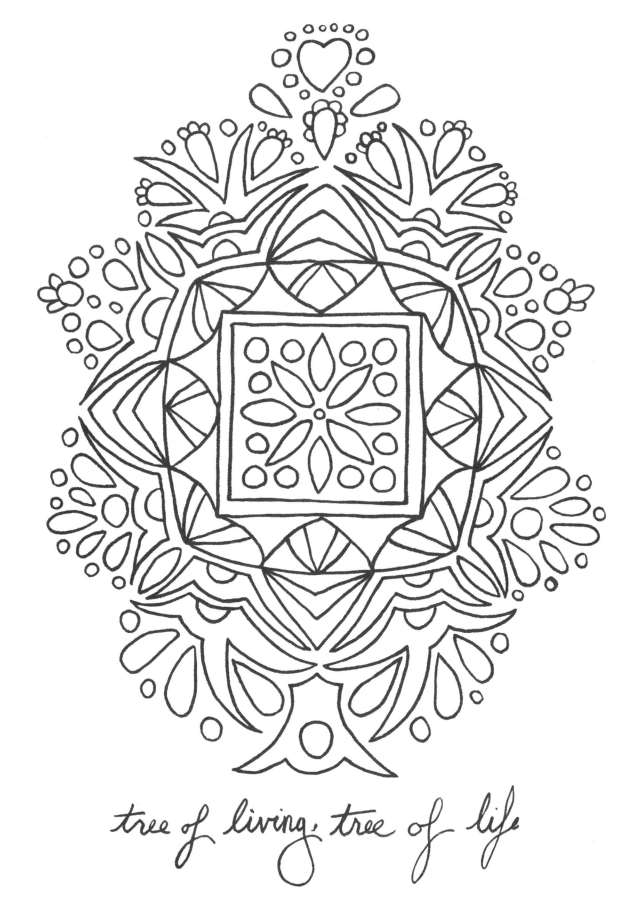

tree of living, tree of life

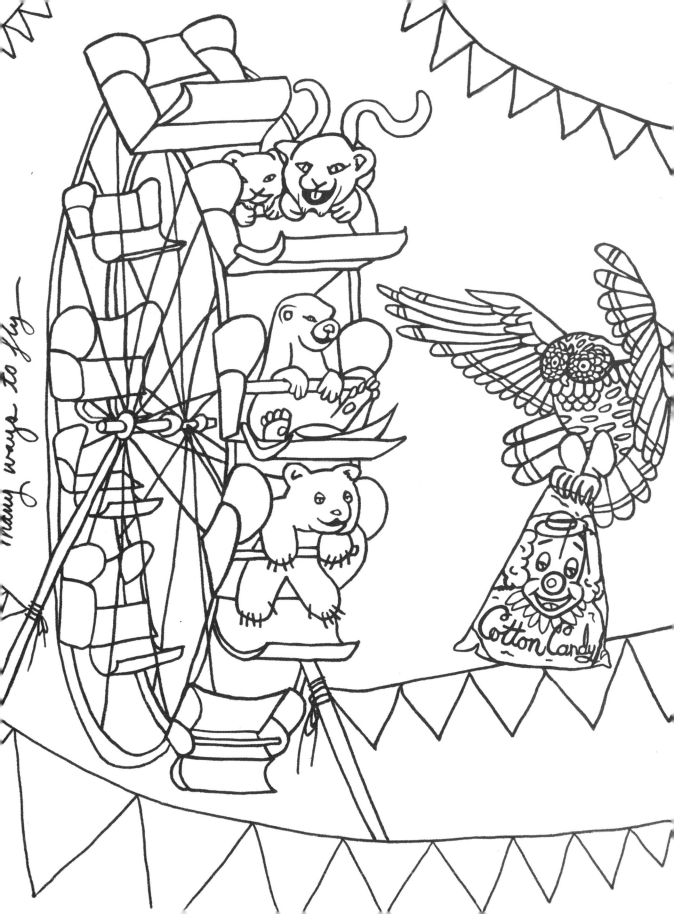

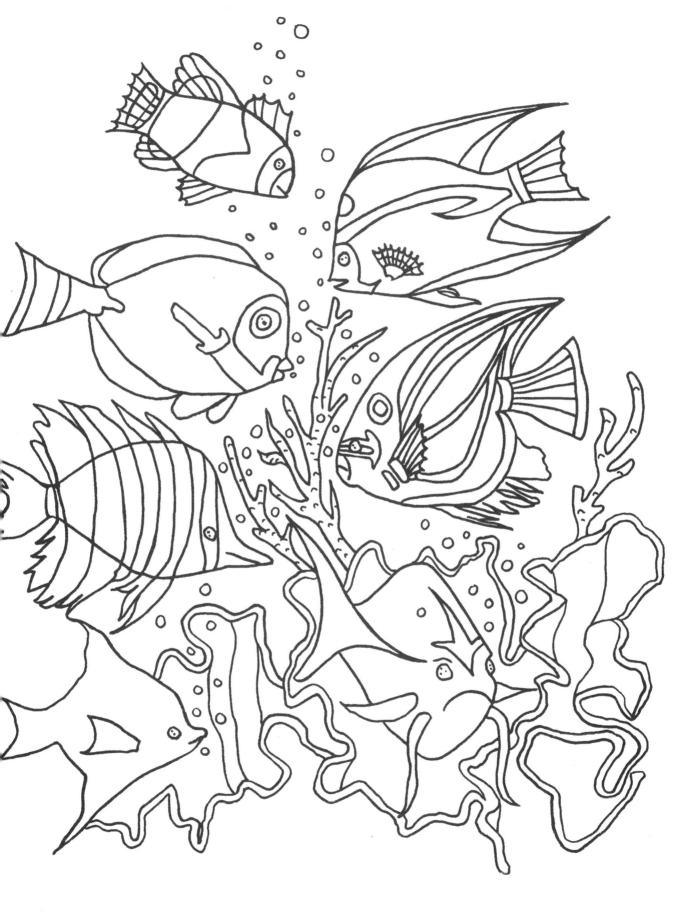

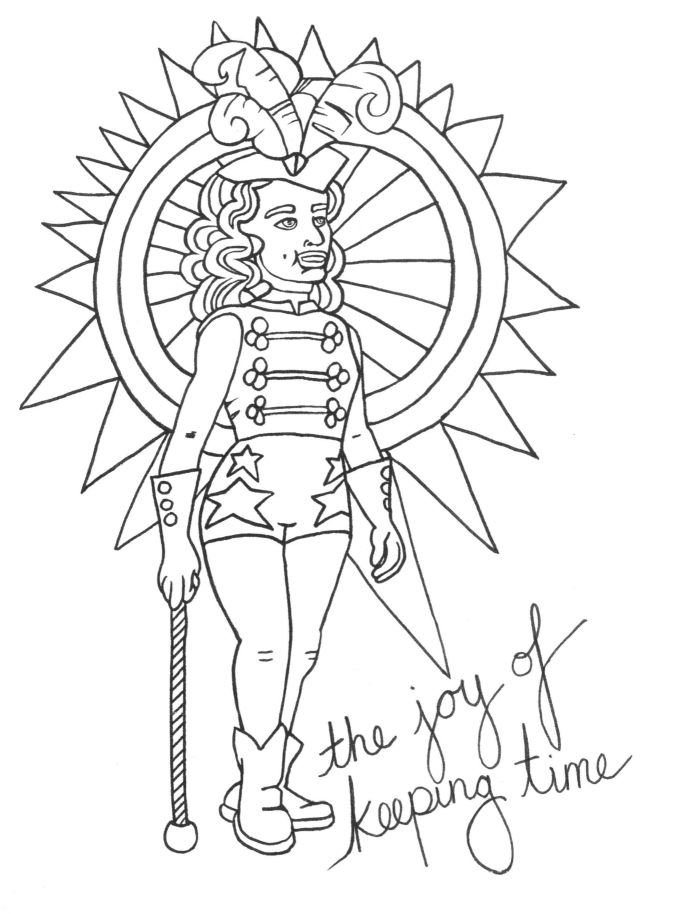

the joy of keeping time

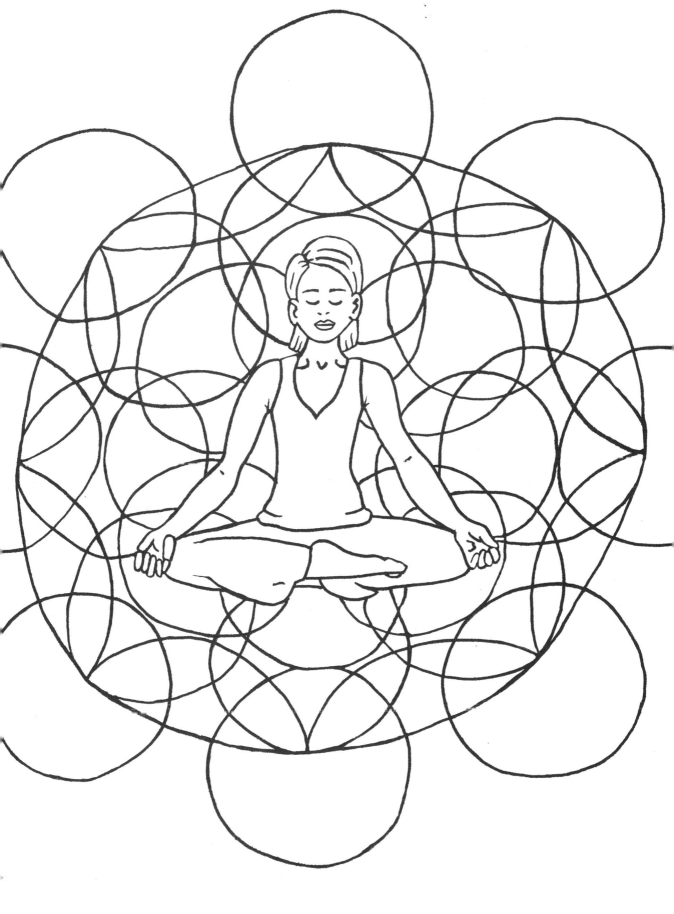

a dik-dik would eat these flowers

the dik-dik is an antelope that stands about a foot tall—it lives in Africa

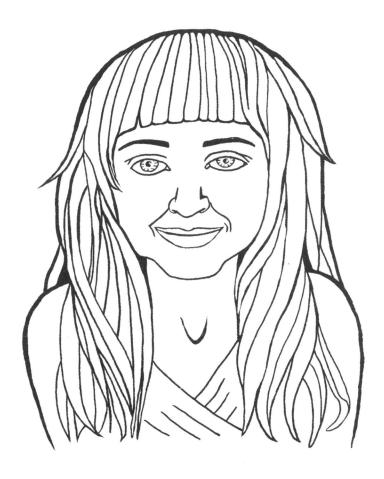

TEVA HARRISON is a writer, artist, and cartoonist. She is the author of the critically acclaimed and bestselling graphic memoir *In-Between Days*, which is based on her graphic series about living with cancer published in *The Walrus*. It was named one of the most anticipated books of 2016 by the *Globe and Mail*, which also named the author one of 16 Torontonians to Watch. She has commented on CBC Radio and in the *Globe and Mail*, and numerous health organizations have invited her to speak publicly on behalf of the metastatic cancer community. She lives in Toronto.